Ancient Empires

OF THE

Eastern Mediterranean

RONALD JOSEPH TOCCHINI

Order this book online at www.trafford.com
or email orders@trafford.com

Most Trafford titles are also available at major online book retailers.

Printed in the United States of America.

ISBN: 978-1-4907-5102-3 (sc)
ISBN: 978-1-4907-5101-6 (hc)
ISBN: 978-1-4907-5100-9 (e)

Trafford rev. 12/18/2014

 www.trafford.com

North America & international
toll-free: 1 888 232 4444 (USA & Canada)
fax: 812 355 4082

Having sailed from Venice in the early afternoon of August 7, 2013, we headed south along the Adriatic in the direction of the Ionian Sea. The bow of our ship, the *Nieuw Amsterdam*, sliced the calm blue waters,

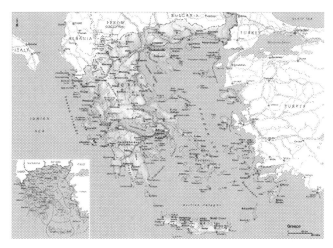

and gradually, we lost sight of the Italian coast off our starboard and that of Yugoslavia off our port.

After venturing forth all night long, we anchored off the west coast of the Peloponnese and visited ancient Olympia, the sanctuary in use for two millennia as a religious and athletic center. Of all the Hellenic competitions associated with shrines, the Olympic Games, held every four years at the late summer with a full moon, were the most prestigious. Moreover, they are the most ancient of their kind. Note that although the first verified games date back to 776 BC, the *Altis*, a sacred forest at the base of *Krónio* hill, was consecrated to pre-Olympian deities as early as the second millennium BC.

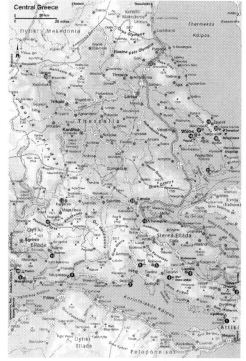

The most salient monuments of the site are (1) the *Palaestra* training center, whose courtyard has been reerected; (2) the workshop of *Phidias*, a celebrated sculptor (identified by a cup found with his name inscribed thereon; (3) the archaic *Hera* temple with its dissimilar columns; (4) the enormous *Zeus* temple, now reduced to column sections; and (5) the stadium with its 192-meter running course and surviving vaulted entrances.

Athens, Piraeus

O ur visit to Olympia was brief but interesting. The next stop on our itinerary was Athens, Greece's capital. To get there from Olympia, we sailed east through *Korinthiakos Kolpos*, a sizable body of water that separates Peloponnisos from Greece's mainland.

Having docked at *Piraeus*, the capital's port, we went ashore and

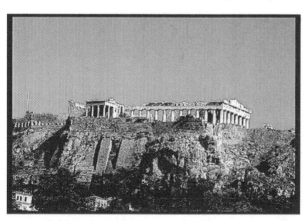

began to tour the city. Our first site was the ancient *Acropolis*. Nowadays, the latter looks like a stonemason's workshop, much as it must have looked in 440 BC when the *Parthenon* was under construction as the crowning glory of Pericles's giant public works program.

The *Erechtheion*—an elegant, architecturally complex repository of ancient cults going back to the Bronze Age—is already restored.

Completed in 395 BC, a generation later than the *Parthenon*, the *Erechtheion* also housed a wooden statue of Athena, along with the legendary olive tree that she conjured out of the rock to defeat *Poseidon*, the sea god, in their contest over *Attica*.

The *Propylaia*—a battered official entrance to the Acropolis—was built by *Mnesikles* in 430 BC. Cleverly designed with imposing outside columns, the said entrance served as a spectacle that awed visitors that were coming up the hill. Parts of its coffered stone ceiling, once painted and gilded, are still visible as you walk through the *Athena Nike*, an exquisite

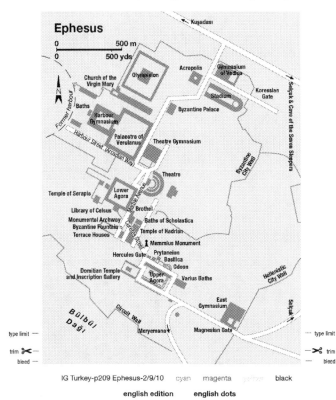

square temple (finished in 421 BC) that stood on what was once the citadel's southern bastion. It supposedly occupied a spot where Theseus's father, King Aegeus, is believed to have thrown himself to his death upon seeing a black-sailed ship approaching the harbor. What happened was that Theseus had promised to hoist a white sail for the return voyage if he had succeeded in killing the *Minotaur* on Crete, but carelessly, he forgot to do so.

The New Acropolis Museum from the outside is somewhat unappealing. Built of concrete and glass, it has a modern twentieth-century feel that doesn't complement the general aspect of the citadel's look of antiquity. Inside, however, the building looks much better. The harnessing of natural light allows for the optimum presentation of sculptural objects. Interesting too is the sensation one experiences when entering the museum. For example, you walk on a glass walkway over recently excavated sections of ancient Athens, including dwellings, wells, waterworks and sewage works, an olive press, and even a classical symposium hall with mosaic flooring.

The lowest gallery of the museum houses findings from the Acropolis slopes. Leading to the upper levels is a ramp; the latter simulates the approach to the Acropolis and is watched over by six scarred female caryatids. On the first floor, the archaic exhibition features the famous Calf Bearer or Moschophoros and various coquettish *Rorai*. These appear to reveal a preclassical ideal of beauty. Look closely, and you can actually discern their makeup, earrings, and the patters of their crinkled, close-fitting dresses. Then up on the top floor, you can see what some consider to be the *pièce de résistance*: a glass gallery holding a reconstruction of the Parthenon pediments of the same size and compass orientation as those of the real Parthenon looming just outside the windows. Friezes, including a triangular western aetoma, are mounted at eye level. This is in contrast to the originals, which sat overshadowed by the eaves so that the ancient Athenians could not appreciate them. The authentic fragments, which Greece retains, have been mounted; everything else is a plaster cast, pointedly awaiting the return of some prototypes; i.e., the so-called Elgin Marbles were acquired by the British Museum in London.

The ancient Greek Agora is located just to the north of the Acropolis. While the Acropolis was mainly a religious site, the Agora was used for all public purposes: commercial, religious, political, civic, educational,

theatrical, and athletic. Presently, it looks like a cluttered field of ruins which, sadly, is a condition not uncommon to ancient Greek buildings.

The Stoa of Attalos, a reconstructed site dated back to the second century BC, contains a splendid archaeological museum. Moreover, the Hephaisteion (also known as Theseion), the temple on the opposite side, is the most complete surviving Doric order temple, and it gives some idea of what the Parthenon looked like.

Across from the aforementioned Greek Agora, one corner of the Painted Stoa has been exposed. This building gave its name to stoicism, the stiff-upper-lip brand of philosophy that Zeno, the Cypriot, taught there in the third century BC.

On the south side of the Acropolis lies the Theater of Dionysus. The marble seating tiers date from around 320 BC and later, but scholars generally agree that plays by playwrights such as Aeschylus, Sophocles, Euripides, and Aristophanes were first staged here at religious festivals during the fifth century BC.

In Athens, past Monastiraki, there is the Kerameiko's Cemetery, which was a burial place for prominent ancient Athenians. An extraordinary variety of sculptured monuments are found; i.e., there are tall stoneworks, a prancing bull, winged sphinxes, and melancholy scenes of farewell. You see them overlooking the paved Sacred Way leading to the Dipylon Gate from Eleusis, where mysteries were held. The site museum's collection of grave goods is an excellent guide to Greek vase painting. For example, you see squat geometric urns with rusting iron swords twisted around their necks to white *lekythoi* of classical Athens and sophisticated Hellenistic pottery. Also in the area is the Benaki Museum's Islamic art collection which, according to some experts, ranks among the best in the world. More than eight thousand works of art chart the evolution of Islamic art and civilization up to the nineteenth century. The superb display includes a sixteenth-century velvet saddle

from Bursa and the marble-faced interior of a seventeenth-century Cairo reception room.

At the southern end of the Plàka-Anafiòtika District of Athens is the Choragic Monument to Lysicrates. This is important since it is the earliest example of the use of external Corinthian columns (the latest and most ornate order of ancient Greek architecture). The inscription commemorates the victory of Lysicrates in 334 BC in a drama contest.

Roman Athens. The second-century emperor, Hadrian, a fervent admirer of classical Greek culture, erected an ornate arch, marking the spot where the classical city ended and the provincial Roman university town began. On the side facing the Acropolis is the inscription "This is Athens, the ancient city of Theseus"; on the side facing the Olympieion, it reads: "This is the city of Hadrian and not of Theseus." Little of this Roman city can be seen beneath the green of the Zappio Park and the archaeological area behind the towering columns of the Temple of Olympian Zeus, but recent excavations in a corner of Zappio Park indicate that Roman buildings in this area, including public baths, extended at least to the stadium built by Herodes Atticus. Work on the Temple of Zeus had been abandoned in around 520 BC when funds ran out, but Emperor Hadrian finished the construction and dedicated the temple to himself.

Below, the Tower of the Winds

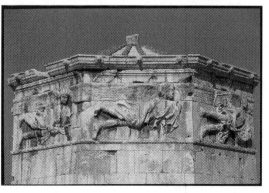

Herodes Atticus, a wealthy, green landowner who served in the Roman Senate, built the steeply raked theater on the south slope of the Acropolis. The Herodes Atticus Theater, now used for Athens's festival

performances, was built by Herodes Atticus as a memorial to his wife. And a Syrian in the first century BC was responsible for constructing the picturesque Tower of the Winds in the Roman Agora. The said tower is a well-preserved marble octagon overlooking the scanty remains of the Roman Agora. It is decorated with eight relief figures, each depicting a different wind direction. Later in time, it served as a *tekke* for the Ottoman dervishes.

Pláka, the old quarter of Athens clustering at the foot of the Acropolis, has been refurbished and restored to its former condition. The more garish establishments have been closed down, and cars have been prohibited. Houses have been repainted and streets tidied up. It has become a delightful place in which to meander.

Pláka is also a good place to review Athens's Ottoman past. For example, the fifteenth-century Fethiye Mosque in the Roman Agora is one of the finest and oldest models of Muslim architecture in the city. Nearby on Platía Monastiraki is the Tsisdarakis Mosque, which dates back to 1759. The interior of this mosque has been sensitively conserved. However, perhaps the most fascinating remnant of Turkish life is the sixteenth-century Abdi Efendi hammam on Kirristou. This *hammam* (Turkish bath) has been beautifully restored.

Aside from the museums already mentioned, the Pláka quarter has a number of other excellent ones. Chief among these is the Museum of Greek Folk Art on Kydathinéon. Famous for its superb collection of regional Greek costumes, including carnival costumes from the *dodekámero* (twelve days of Christmas) and the disturbing *géros* disguise from Skýros.

Opposite the Museum of Greek Folk Art is the children's museum. Geared toward play, this is a good place to visit if you have children. After you have rung the doorbell to be admitted, you find yourself in a cool, modern interior full of exemplary displays. The museum is illustrative of

the long history of Jewish settlement, and tolerance toward it, in this part of the world.

The Paul and Alexandra Kanellopoulos Archaeological and Byzantine Museums are housed in a nineteenth century mansion in Anafiótica. It is a smaller treasure trove of objects from many periods of Greek art acquired by erudite collectors. Also in the Pláka and housed in a neoclassic mansion is the excellent Museum of Popular Instruments, Research Center for Ethnomusicology, based around the collection of Fivos Anoyanakis. The museum divides the exhibits into aerophones (blown instruments, such as the *flogéra* or reed flute), chordophones (stringed instruments, like *bouzouki*), idiophones (instruments where the sound is produced by its body, like cymbals), and membranophones (drums). Each can be heard at adjacent listening posts.

Monastiraki is essentially Athens's bazaar, a huge sprawl of shops. The area brings to mind the market described in a fourth century BC comedy by Eubouleus. Literally everything from soup to nuts is for sale at the bazaar. Monastiraki Square, by the metro station, is currently in the process of a thorough overhaul to make it more attractive and inviting.

The whole area still has rough zones, as one can see in the shops around the Mitrópolis, the city's cathedral. The cathedral dates from the mid–nineteenth century. Next door to the cathedral is the much smaller cathedral, which dates from the twelfth century.

In the flea market and its environs, you step back in time into an almost pre-industrial era. Imagine shops selling all things conceivable.

The goods in old Varvakio are not as varied as those of the flea market. Varvakio is the city's main covered-meat-and-fish market. Fruits and vegetables are available in an open section of the market.

Omónia to Syntagma. The city's heart lies within an almost equilateral triangle defined by Platía Omónias in the north, Monastiráki in the

south, and Platía Syndágmatos to the southeast. Except for three small cross streets, no cars are permitted in this area, which means it has taken on a new lease on life.

The National Archaeological Museum lies north of Omónia. It is crammed with treasures from every period of antiquity. Some years ago, its redesigned Egyptian galleries were unveiled. Work was recently completed, and the restructured museum has reopened its doors. It is truly one of the city's most important sights.

The neoclassical front of the National Library of Greece; *below*, the National Archaeological Museum

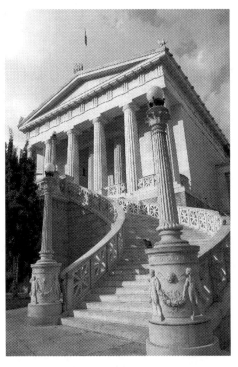

Omónia itself went in for a face-lift at the millennium. However, it is plagued with traffic, and the somewhat bleak concrete piazza that now covers the center of the busy square has been criticized and rejected. Not far from Omónia is Christian and Theophilus Hansen's neoclassical trilogy of the national library, university, and academy, erected between 1839 and 1891; they are built of Pentelic marble and draw heavily on ancient Greek architectural forms. Behind the university is the small Hellenic Theater Museum, which has a charming series of recreated changing rooms of famous Greek actors, including Maria Callas. The national historical museum occupies the prominent old parliament building. It recounts the history of Greece from the fall of Constantinople in 1453 to World War II.

Sýndagma Square (*Platía Syndá gmatos,* constitution square) is the center of the city. It has been pleasantly and tastefully landscaped.

Ermou, running west from the square, used to be a traffic-clogged mess, but it is now a long pedestrian walkway with reinvigorated shops, enlivened by shoppers. Many buildings on this street have been refurbished, and improved lighting makes this an attractive area to stroll in the evening. Also on Ermou is the attractive Byzantine church of Kapnikarea, which is thought to date from the eleventh century.

The National Gardens are just behind the parliament building. They are full of tangled bowers, romantic arbors, and quiet fishponds. There are also faint trickles of water running along secret, leafy troughs. It was laid out by Queen Amalia in the nineteenth century and was referred to as the palace gardens. It contains a wide variety of different kinds of plants and flowers from all parts of the world.

Kolonáki. Chic and expensive, Kolonáki is Athens's upmarket shopping district, as well as being the site of many diplomatic missions and some highly desirable apartments. This district also has some of the finest museums.

Below, the Museum of Cycladic Art

Going back to 3000 BC, the Goulandris Museum of Cycladic Art displays a unique collection of slim, stylized Cycladic statuettes in white marble, beautifully mounted. Their smooth, simple lines attract both Picasso and Modigliani. Mostly female and

pregnant, the figures derive from robbed graves scattered throughout the Cycladic islands.

The Benáki Museum is thought by some to be the best museum in Athens. It has an eclectic collection of treasures from all periods of Greek history. The collection also includes jewelry, costumes, and two icons attributed to El Greco. Among the most impressive displays are the collection of traditional costumes, mostly bridal and festival dresses, and the reconstructed reception rooms of a mid–eighteenth-century Kozani mansion. Also of great interest are the displays of gold on the ground floor and the objects that relate to the Greek struggle for independence.

Mount Lycabettus (*Lykavitós*, 215 meters high) rises above Kolonáki, which is crowned by the tiny chapel of Ágior Geórgios. The easiest and most scenic way to get to the summit is by the funicular railway that starts from Ploutárhou Street, near Platía Kolonáki. From the summit of Mount *Lykavitós*, the views of Athens are spectacular.

Close to Kolonáki are two other museums that are worth a visit. The Byzantine and Christian museums are housed in a mock Tuscan villa. It was commissioned by the nineteenth-century French Duchesse de Plaisance. This museum is most famous for its brilliant array of icons and church relics from the thirteenth to the eighteenth centuries. Notorious too is its long-running project to construct multilevel, semi-underground galleries, state-of-the-art workshops, and educational facilities. Just imagine all of the latter surrounded by an outdoor archaeological park. Completed in 2004, the said project has allowed more of the museum's huge collection to be on permanent display.

The national gallery and Alexandros Soutzos Museum are a must to visit when you are in Athens. This is a national collection of paintings and sculptures, which is housed in a cool, modern building. It is the Greek paintings here that are best because they are illustrative and symbolic of national sentiment. Particularly interesting are the works from the

Ionian school, the realistic late nineteenth-century works, and the ones that approach the more Greek sensibility of the early twentieth century.

Eleftherías Park was the location of the HQ of the military police, where dissidents were detained and tortured during the military dictatorship (1967–74). After the fall of the junta, the site was turned into a park and cultural center. It was extended and replanted with more than two hundred trees and shrubs in 2001–2002.

Byzantine Athens. Of the city's Byzantine past, little remains but a dozen or so churches, many of which date back to the eleventh century, can be seen in Pláka. An excellent example is the Ágii Theodori, just off the Platía Klavthmónos. It was built in the eleventh century in a characteristic cruciform shape with a tiled dome. The masonry is picked out with slabs of brick and decorated with a terracotta frieze of animals and plants. The church of Sotíra Lycodímou, which dates from the same era, was purchased by the Tsar of Russia in 1845 and redecorated. It currently serves the city's small Orthodox community. The singing at services is said to be superb.

Two monasteries, Kaisarianí on Athens's east side and Dafni on its west side, hold a special place in the city's history. Kaisarianí is located on Mount Hymettus. Surrounded by high walls, it is named after a spring that fed an aqueduct. This was constructed on Hadrian's orders. Its waters, once sacred to Aphrodite, the goddess of love, were long credited with healing powers and encouraging childbearing. The monastery church goes back to AD 1000, but the frescoed figures, which gaze out of a blue-black ground, date from the seventeenth century. The monks' wealth is from olive groves, beehives, vineyards, and various medicines made from mountain herbs.

Dafni is the second of two monasteries mentioned in these pages. It is out of town, on the road to Eleusis. Small compared to Kaisarianí, Dafni is a curious architectural combination of Gothic and Byzantine

styles. Decorated inside with magnificent eleventh-century mosaics, it also occupies the ancient site of an ancient sanctuary of Apollo. A fierce-looking Christ Pantocrator, set in gold and surrounded by Old Testament prophets, stares down from the vault of the dome. The building dates from 1080, and a Gothic porch was added in the thirteenth century when Dafni belonged to Cistercian monks from Burgundy and also was used as a burial place of the Frankish dukes of Athens.

Piraeus. Athens's port, Piraeus, a city in its own right, is where most people pass through on their way to the islands.

Piraeus's archaeological museum has a number of wonderful bronzes. On the first floor is the graceful, archaic Apollo *kouros*, which was pulled from the sea in 1959. Made in 530–520 BC, it is the earliest, life-sized bronze statue. There are two other bronze statues, one of Athena and the other of Artemis. Both dating to the fifth century BC, they were found in Piraeus. There is a further superb bronze statue of Artemis, one which dates from the mid–ninth century BC. Also on the ground floor is the restored mausoleum of an Istrian merchant.

The Hellenic Maritime Museum, full of models of ships from all ages, is close by on Zea Marina (*Akti Themistokléous*). Crowded with medium-sized yachts, Zea Marina is a floating campsite in summer. Picture it in your imagination: you may see old-fashioned huge two-masters and three-masters, as well as sleek motor yachts moored. Moreover, further around the headland are cafés and fish restaurants overlooking the Saronic Gulf.

Athens is said to have eight hills, as well as Lykavitos and the equally conspicuous rocks of the Acropolis, flanked by the Pnyx on one side and the hill of Philoppapos on the other. See the hill of Ardittós next to the stadium built by Herodes Atticus in AD 143, and observe the Hill of the Nymphs, capped by the gray dome of the observatory; also view the barren, windblown Tourkovoúnia and the hill of Lófos Stréfi.

Mount Hymettus (*ymettós*)—5 km east of Athens, beloved of honeybees, glowing violet at sunset—is perhaps the most beautiful of the three mountains that encircle Athens. Driving up the winding road past the monastery of Kesariani, you reach a tranquil vantage point from which to observe all of Attica. This city is panoramically visible yet totally, eerily inaudible. That is to say, you gaze at the activity in Attica, but you hear nothing of the sound. Mount Parnitha (*Párnis*), just over an hour to the northwest, was sadly burnt to a crisp in August 2007, losing all its fir forest. In contrast, however, is Mount Pendéli, which is to the north of Athens. You will notice that it is crowded, lively, and popular.

Below Mount Pendéli is Athens's most exclusive suburb, Kifisiá. Populated like Kolonáki, it is a pleasant place to hang out in one of its expensive cafés. Also in Kifisiá are the famous Goulandris Museum of Natural History and Gaia Center, which has some very informative collections devoted to flora, fauna, and geology of Greece.

Still outside Athens, a 69 km drive to Cape Sounion on the windy tip of the Attica Peninsula takes you to the Doric Temple of Poseidon. Completed in 440 BC, its slender salt-white columns are still a landmark for ships headed toward Piraeus. Lord Byron, the famous English poet, carved his name on a column on the north side. The marble for the construction of the temple came from nearby Agíleza. Down the hillsides, overlooking the sea, you can see the remains of ancient ship sheds in the azure bay below. Interesting to note is the fact that Athenians used to organize warship races off Cape Sounion. Such an activity resembled that

of the ancient Romans, who would flood the coliseum in order to recreate naval battles.

Poseidon

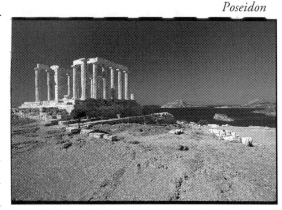

The Battle of Marathon in 490 BC was fought on a plain near the sea, 42 km northeast of Athens, between the villages of Néa Mákri and Marathónas. What you can see today associated with the battle is the burial mound of Athenians, the burial mound identified as that of the Plataeans and the archaeological museum.

The burial mound of the Athenians is a circular mound of earth, nine meters high, fifty meters in diameter, and 185 meters in circumference. It is impressive but nothing compared to the victory it symbolizes. The mighty Persian Empire, the largest on earth, had sent its army against Athens, and about nine thousand Athenian soldiers were joined before the battle from Plataea, a town in Boeotia. The Athenians won against overwhelming odds, with the Persians losing 6,400 men and the Athenians 192. The Athenians were cremated and buried together in the mound. The mound of the Plataeans is near the archaeological museum, about 3 km to the west. There is nothing to mark the Persian graves.

Ramnous, the site of an ancient fortress town on the northern borders of Attica with a sanctuary of Nemesis, is 53 km from Athens. The sanctuary contains two temples. The older temple, built right after 490 BC, was dedicated to Nemesis and also to Themis, the god of justice. The slightly larger Doric temple of Nemesis, built in 436–32 BC, almost touches the older temple.

Oropos was the city state that built the sanctuary of Amphiareion in the fifth century BC. The ancient city is now buried beneath the modern town of Skála Oropós. The sanctuary was particularly well-known in the Hellenistic period when it was visited by people from all over the Greek world in search of advice or medical help. The supplicant sacrificed a ram to Amphiaraos, after which a dream would either cure the illness or answer a question.

The sanctuary of Artemis at Brauron (now called Vravróna) is located on the east coast of Attica, 35 km from Athens. There is a fifth-century colonnade flanked by a sixteenth-century Byzantine chapel, which is built on the side of an altar to Artemis. In classical times, well-born female children, aged from five to ten, performed a ritual dance at a festival, honoring Artemis as the goddess of childbirth. Their statues—plump with solemn expressions and dressed like adults—are now in the site museum.

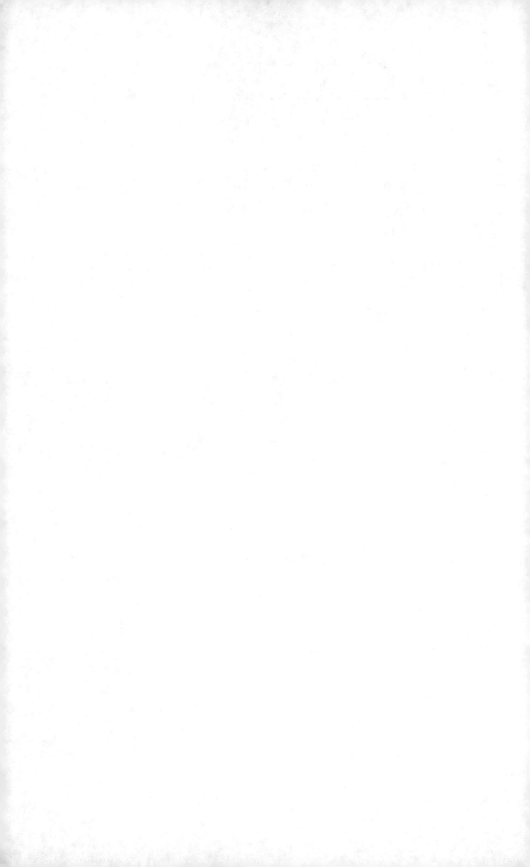

Turkey

The next stop of our journey was Istanbul, Turkey. What a beautiful sight! Surely, we had never seen anything like it. Let's take a look. New Istanbul is a mix of Ottoman alleys, Art Nouveau mansions, and steel and glass skyscrapers. To the east, dividing Europe and Asia, is the Bosphorus. Lined with handsome summerhouses and attractive fishing harbors, it begs the attention of visitors from all over the planet.

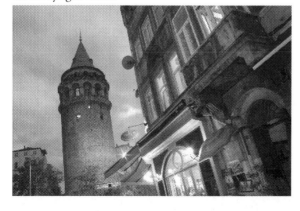

Below, the Galata Tower looks down on a Beyoğlu Street

The foregoing area is loosely termed "*Beyoğlu.*" That is to say, it is the area north of the Golden Horn, the one which stretches from the fourteenth-century Galata Tower to the swinging nightclub district of Taksim. Most of the buildings are of architecture that dates back to the fifteenth and sixteenth centuries,

and its history is predominantly one of foreign settlement. Most intriguing, it was the designated European Quarter during Ottoman times, earning a reputation for both culture and debauchery. This attracted curious Muslims and off-duty janissary soldiers. As we toured the area, I was reminded of San Francisco, particularly its North Beach and International Settlement.

Later on, the foregoing area was settled by other minorities who were welcomed by the Ottomans. The ensuing cultural cosmopolitanism has survived to the present day through the impact of Greek, Jewish, Armenian, Italian, Russian, and other settlers, whether merchants, natives, or refugees. Today, it is still the part of town that is most popular with expat foreigners, who continue a long-established tradition of making homes here.

The original Greek name for the area is Pera, meaning "beyond" or "across" from the other city. By the seventeenth century, it had become synonymous with taverns and licentiousness. Prostitution, both male and female, was (and still is) overlooked by authorities.

In the nineteenth century and early twentieth century, the Western powers built their embassies here, thereby imprinting a European stamp on the neighborhood.

Istanbul has remained the undisputed commercial and cultural hub of the nation even though it was dethroned in 1923, and Ankara was declared the capital of the new republic of Turkey. Istanbul is where all new trends in art, literature, music, and film begin and where most of the money is made and kept.

The foregoing has caused somewhat of a conflict within the social makeup of the city. That is to say, many poor rural migrants from the troubled East frequently pour into Istanbul, looking for employment only to find themselves treated as second-class citizens. All too often, they fell easy

prey to the utopian promises of radical Islam. Today, the Galata area near the bridge is conservatively Islamic, settled primarily by migrants. Despite this fact, the migrants have introduced fashionable restaurants and teahouses.

In the face of the above-mentioned conservatism, the area's once famous nightlife has moved uphill to Tünel, where an underground funicular railway deposits visitors in super trendy Asmalimescit. Meanwhile, the area has become somewhat touristy.

The Galata Bridge (*Galata Koprüsü*) connects Eminönü with Karaköy, thereby linking the old city to the new. The said bridge seems so crucial to getting around today that it seems hard to believe there was no permanent crossing point here until the nineteenth century.

Karaköy is home to a lively small fish market, as well as ferries to Kadikoy and Haydarpasa stations. It's also where the cruise ships dock to unload thousands of tourists into the old city. Istanbul Modern was originally a customs warehouse, farther east along the pier at Karaköy. Today, it houses contemporary Turkish paintings, sculpture, photography, video and sound installations. It also has regular touring exhibitions, an art house cinema, and a chic café bar.

Below, the restored historic tram runs along Istiklal Caddesi from Taksim to Tünel

From Karaköy, most people ascend to Galata and Tepebaşi using the Tünel, a short funicular railway that leaves from a street best known to Istanbul residents for its many hardware and

21

lighting shops. Galata Tower (*Galata Kulesi*) was built as a watchtower in 1348 by Genoese settlers who had been granted free trade and semi-independent status. My travelling partners and I took an elevator to the top for a sweeping view of the city. The square at the bottom of the tower is a popular meeting place.

Beyoğlu and Galata are also home to churches of various denominations. There are several synagogues, including the Neve Shalom. This was the target of a massive al-Qaeda bomb that killed twenty-five people in 2003. Most of Istanbul's Jewish community is Sephardic, Spanish Jews who were forced to flee from their home in Spain as a result of the Spanish Inquisition of 1492.

Muslim minorities were also welcomed by the Turks. You are encouraged to visit the Galata Mevlevihanesi, a particular open-minded center that is officially a museum.

The Tünel funicular from Karaköy deposits you at the western end of Istiklal Caddesi. This is the main street through the new town, running from Tünel to Taksim Square. It is primarily dedicated to shopping, entertainment, and culture. Just over 1.5 km long, it is serviced by an atmospheric old train, which trundles along the pedestrianized street. The Pera Museum, housed in the handsome old Hotel Bristol, has first-rate nineteenth-century Turkish portraits, paintings, and porcelain. The Pera Palas Oteli, made famous by the author, Agatha Christie, was built to accommodate passengers from the Orient Express. Its lobbies are cluttered with nineteenth-century furniture, and its plush corridors are redolent with intrigue.

The Asmalimescit district, a warren of alleyways leading off Istiklal Caddesi to the north of Tünel, has become particularly fashionable. Tepebaşi, the area around the Pera Museum and the Pera Palace Hotel, is similar.

The nightlife zone continues through the lively *meyhanes* of Çiçek Pasaji and Nevizade Sokak to Taksim. Many of the *alternative* nightclubs are found here. In these often decrepit-looking streets are some of the best (and cheapest) small restaurants in town. Here, Russian and Armenian specialties rub up against classic Turkish ones and provide the general sense of international that defines the cultural heart of Istanbul.

Nevizade Sokak runs off the same fish and vegetable market as the more famous Çiçek Pasaji. Moreover, it is where Gypsy musicians and hawkers still stroll on the tables. All the latter offers more of the original flavor of the district.

Taksim, at the far end of Istiklal Caddesi, is the high-rise heartland of modern Istanbul. It is best described as a bustling, raucous cacophony of plate glass and designer restaurants. In Taksim Square, a major transport hub, you see the Cumhuriyet Aniti. Created by Italian sculptor Pietro Canonica, it depicts Atatürk among the founders of modern Turkey. It is flanked by an enormous Turkish flag.

The Askeri Muzesi (*Military Museum*) has an interesting collection of weaponry, elaborate costumes, and some impressive embroidered tents from Ottoman military campaigns.

The Dolmabahce Sarayi (*Dolmabahce Palace*) was the nineteenth-century vision of Sultan Abdülmecid. It represents everything that is jarring about Istanbul aesthetics. Atatürk died here. Abdülmecid died shortly after the palace's completion. His successor and brother, Abdülaziz, was so disgusted with the building that he built his own.

According to legend, the Bosphorus (*Ford of the Cow*) gained its name when Zeus, playing away from home, had an affair with the beautiful goddess Lo. Jealous Hera sent a swarm of gnats to irritate Lo. For some

inexplicable reason, she turned herself into a heifer to swim the channel and escape.

Since Greek times, the deep 32-km strait linking east and west has been one of the most strategically significant waterways in the world, witnessing the arrival of the first Greek settlers of Byzantium. Currently, about 55,000 ships pass through the straits yearly, mainly due to the huge export demand for Russian, Central Asian, and Caucasian oil.

In the late Ottoman period, the Bosphorus shore was occupied by villagers and summer residences for aristocrats attracted by the cool breezes and forests. The pashas built themselves stone palaces or wooden mansions.

Both European and Asian shores are desirable places to live since they are dotted with seafood restaurants and modern dwellings.

Crossing the Bosphorus from Üsküdar to Beşiktas.

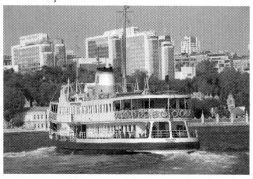

Cruising the Bosphorus is relatively inexpensive. Round trips leave from the main ferry dock at Eminönü, close to the southern end of the Galata Bridge. Each cruise takes two hours each way, with a stop for lunch in Anadolu Kavaği on the Asian side near the Black Sea.

The circular tour passes through the mouth of the Golden Horn, with the Topkapi and Seraglio point to your right. Midstream is Kiz Kulesi, a Greek watchtower rebuilt as a lighthouse in the twelfth century

and completely remodeled several times since. Dolmabahçe Sarayi—a quintessential example of Baroque construction—is on your left.

Next up along the European waterfront is the Cirağan Sarayi, also built by Abdülaziz. Burned to a shell in the 1920s, it has been restored as the luxury Çirağan Hotel Kempinski complex. Behind it, on the slopes leading uphill, is the attractive Yildiz Park. Near the Beşiktas ferry dock stands the Deniz Müzesi or Naval Museum, which displays some of the elaborate *caïques* (boats) used by sultans to move from one waterfront palace to another.

The First Bosphorus Bridge, built in 1973, is one of the world's longest single-span bridges. Beneath it, the once modest village of Ortakoy has ceded its waterfront to a succession of trendy shops, bars, and restaurants.

Arnavutköy (*Albanian village*) is known for its wooden mansions in Art Nouveau style. Farther north are wealthy Bebek houses, the Aşiyan Museum, and a long strip of waterfront restaurants, bars, and cafés.

Asian Anadolu Hisari and European Rumeli Hisari mark the gates to the Black Sea. Built in 1452 by Sultan Mehmet, the two fortifications were to choke off aid to beleaguered Constantinople during the final siege of the city.

Beyond the Second Bosphorus Bridge, the village of Emirgan is home to the Sakip Sabanci Muzesi, a magnificent private museum displaying fine and decorative art.

At Sariyer, two fine old mansions house the Sadberk Hanim Museum with evocative displays of archaeological finds and nineteenth-century life.

Not everyone wants or has time to take a full Bosphorus cruise. However, it's quite easy to get a ferry at Eminönü and head across to the

Asian side of Istanbul at Kadiköy. This has a delightful market area whose cobbled narrow streets are always packed with shoppers.

An alternative destination accessible by ferry from Eminönü is Üsküdar, a far more conservative Asian suburb that is adorned with many magnificent mosques. As soon as you disembark from the ferry, you will see the first of them, the Iskele Camii (also called Mihrimah Sultan Mosque). Facing it is a fine eighteenth-century fountain, rather like the one in front of the gate leading into Topkapi Palace.

To see more of the old mosques, you should walk along the waterfront in the direction of Kadiköy. This route will take you past the Semsi Paşa Camii, which dates back to 1580, and then it leads you along the stretches of the shore that has been given a promenade. This is Salacak. Here you can catch a ferry for the short hop out to Kiz Kulesi, the Maiden's Tower, a prominent and much photographed landmark tower. The latter has served all sorts of functions over the years but now is essentially a café with views. The "maiden," after whom the tower was named, was a girl whose father had been told she would die from a snakebite. To guard against such a disaster, he had her confined to the offshore tower where she was sent a basket of fruit that turned out to contain the lethal snake.

If you journey inland from the shore at Salacak, you'll find the Rum Mehmet Paşa Camii, which looks like a Byzantine church. You will also find the imposing eighteenth-century Ayazma Camii, which was named after a

Below, traveling by horse-drawn carriage around Büyukada, one of the Princes' Islands

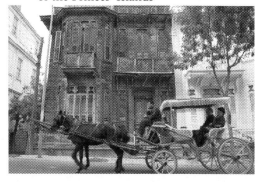

sacred spring in the ground. Finally, if you keep walking straight and uphill, you will arrive at Atik Valide Sultan Camii, one of architect Sinan's finest works.

Head north from Üsküdar, beyond the First Bosphorus Bridge, and see the nineteenth-century Beylerbeyi Sarayi, built by Sultan Abdülaziz after he had taken an intense dislike to the Dolmabahçe Palace recently built by his father, Abdülmecit.

The Princes' Islands in the sea of Marmara are the perfect city getaways, far enough away to escape the heat and fumes of Istanbul but near enough to be accessible by ferry from the mainland. There are nine of these islands, but only four of them are regularly inhabited: Kinaliada, Burgazada, Heybeliada, and Büyükada.

Ferries to the islands stop at each of them, and in theory, you could squeeze a visit to them all in one day.

Büyükada (*Big Island*) is the last stop on the ferry run, and it is the most popular because it offers the greatest choice of places to eat and drink. Also, it offers the chance to climb uphill to St. George's Monastery. While you are in Büyükada, it is also worth taking a stroll along Çankaya Caddesi to appreciate the beautiful wooden houses.

The island of Heybeliada is dominated by a naval academy. It is also home to the seminary, which once trained all priests who served in the Greek Orthodox churches.

Ephesus (*Efes in Turkish*) appeals to visitors ranging from serious scholars to those with a more casual interest.

Famous historians all relate the same colorful foundation legend for Ephesus. Accordingly, Androklos, who was son of Kodros and king of Athens, had been advised by an oracle to establish a city at a spot

indicated by a fish and a boar. Arriving here in the eleventh century BC, Androklos found some locals frying fish by the seaside; one fish jumped out of the frying pan, scattering live coals and setting on fire a thicket in which a boar was hiding. The boar rushed out and was killed by Androklos, thereby fulfilling the prophesy. The new city was founded at the northern foot of Mount Pion with worship of the Athenians' goddess Artemis. It syncretized easily with the indigenous Anatolian Kybele.

By the sixth century BC, Ephesus had prospered despite any military or political power. This attracted the attention of Lydian King Croesus in 560 BC in addition to other powers.

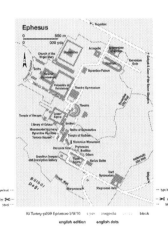

Sarcophagus at Ephesus, most of whose runs date from the Roman imperial period

In 356 BC, tradition states that it was the night of Alexander the Great's birth, when the archaic Artemis Temple was set on fire by Herostratos, who wanted to be remembered for prosperity. His act inspired a Sartre short story and a 2001 Armenian film.

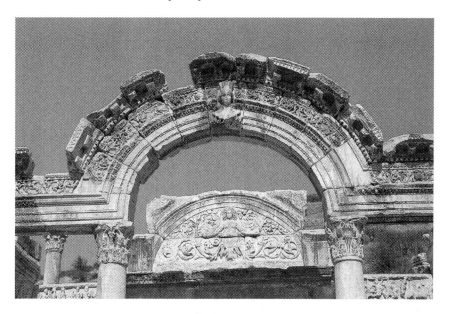

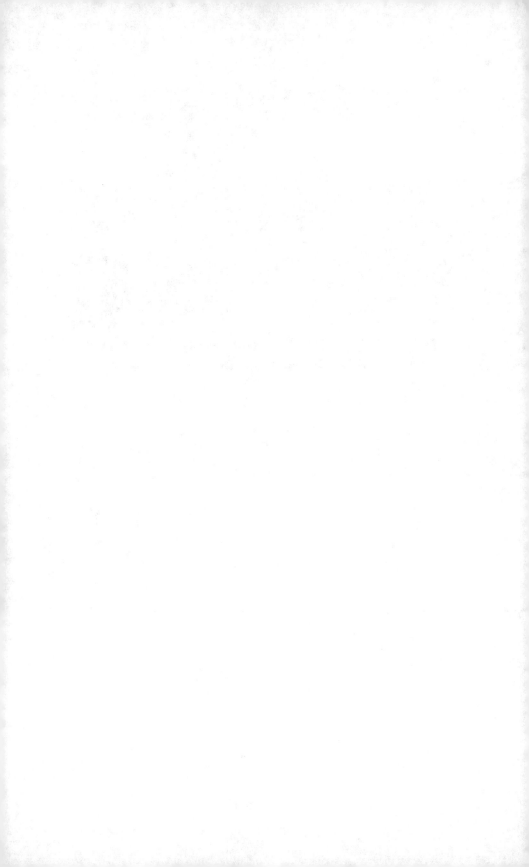

Ephesus

T he Ephesians at once began building an even finer structure, which when completed, ranked as one of the Seven Wonders of the World. Today, a lone Ionian column looms amid a few foundation blocks. It was a pitiful reminder of what was once a glorious structure.

Ephesus reached its zenith during the Roman imperial era, when Augustus declared it as the capital of Asia Minor. During that time, it had a maximum population of 250,000, and it acted as the commercial hub of the Aegean. The only threat to its prosperity was the constant silting up of the harbor by the Kaistros River, today the Küçük Menderes. This fact proved to be an obstacle to shipping.

St. Paul arrived in AD 51 and, within two years, gained enough followers to establish a church in Ephesus. At the same time, Demetrius—head of the Union of Silversmiths who had a lucrative business selling statuettes of Diana, the Roman version of Artemis—was incensed by Paul's proselytizing. Accordingly, he arranged a rally to whip up popular enthusiasm for his cause. Paul wanted to face down the crowd but was discouraged from doing so and therefore left for Macedonia. Yet Christianity spread quickly in Ephesus and eventually supplanted Diana's cult.

Most of the surviving ruins belong to the Roman imperial period. An exception is the circuit wall. It was designed and built by Lysimakhos and is an outstanding example of Hellenistic fortification. It has largely disappeared at lower elevations but stands nearly intact along the crest of Bülbül Daği (*Nightingale Mountain*, the ancient *Mt. Koressos*) to the south of the city.

The northerly access road passes the Gymnasium of Vedius. In typical Roman fashion, the building combined a gymnasium and baths. The adjacent, horseshoe-shaped Hellenistic stadium was restored during Nero's reign (AD 54–68). Across the road stands the Church of the Virgin Mary. It was built in the second century as a warehouse and converted to a basilica in the fourth century AD.

Ephesus's most impressive thoroughfare, Harbor Street (or *Arcadia Way*), which linked the old port and the theater, is named after Byzantine Emperor Arcadius, who remodeled it in AD 395–408. About fifty meters long and eleven meters wide, both sides of the street were covered with porticoes, giving shade onto shops.

Beside Harbor Street, the imposing second-century harbor baths form one of the largest structures in Ephesus, with a thirty meter-long elliptical pool and eleven meter-high marble columns supporting a vaulted brick roof. Next door is the harbor gymnasium that has a colonnaded courtyard paved with mosaic.

The theater, originally constructed during the reign of Lysimakhos into the slopes of the Mt. Pion (today *Panayir Daği*), had a seating capacity of 23,000, and it is still used for the annual May festival. From the top seats, there is a splendid view. Moreover, its excellent acoustics were additionally enhanced in ancient times by the judicious placing of clay or bronze sounding vessels.

Below the theater stands the well-restored Library of Celsus. Its façade, effectively the logo of the city, is like a grandiose film set left behind after the shooting of a Roman spectacular. Behind it and the lower agora lies the Temple of Serapis, which had eight massive columns with Corinthian capitals, each of which weighted fifty-seven tons.

At the library, the road bends and becomes Curetes Street, which extends up to Hercules Gate. At the beginning of the street on the left stand are the Baths of Scholastica. Built in the first century AD, it was reconstructed in the fifth century by the lady whose headless statue can be seen in the entrance hall.

The fascinating Temple of Hadrian, begun in AD 118, has four Corinthian columns supporting an arch with a bust of Tyche, the patron goddess of the city in the center. The plaster cast has three third-century panels depicting gods and goddesses. This is remarkable because the emperor Theodosius, who appears on the foregoing panels with his family, was vehemently opposed to paganism.

The small town of Selçuk, some 23 km northeast of Kuşadasi, owes its importance to its proximity to Ephesus and to the Ephesus Museum. This has an exceptional, well-displayed collection. Floor mosaics and a fresco of Socrates, cult statuettes, coins, and other relics all create a vivid impression of ancient life. Other famous exhibits include a bronze statuette of Eros on a dolphin, a marble one of him embracing Psyche, and two complete marble statues of Artemis, flanked by beasts and adorned with an enigmatic bulbous protuberance, a headless marble statue of Priapus, balancing a tray of fruit (symbolizing fertility).

The Basilica of St. John lies just south of the Byzantine fortress on the hill of Ayasoluk. St. John supposedly lived the last years of his life locally. After his death, a shrine arose over his grave. Emperor Justinian erected a monumental basilica here, which endured until it was destroyed by Tamerlane's Mongols in 1402. The resumed tomb of the evangelist lies at

the altar end of the central nave, under a simple slab. There was a dome that has vanished. It was supported by partly reerected marble and brick pillars, between which stand blue-veined marble columns bearing the monograms of Emperor Justinian and his wife, Theodora. The baptistery, just to the north, with its cruciform plunge pool, dates from the fifth century AD.

At the foot of the hill stands the elegant late fourteenth-century Isa Bey Camii, built in a transition between Selçuk and Ottoman styles.

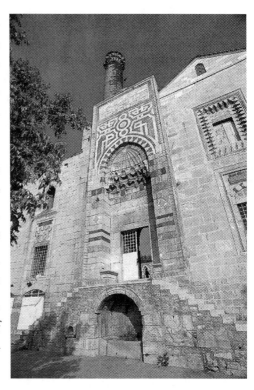

According to one tradition, the Virgin Mary came to Ephesus with St. John and lived here from AD 37 until her death in AD 48. Her purported house (*below*) is referred to as Meryemana. It is located 8 km south of Selçuk. It is now a papally endorsed focus of pilgrimage.

Şirince, a formerly Greek village, only 8 km east of Selçuk, makes a pleasant destination after visiting Ephesus. There is nothing ancient here, just fresh air, traditional houses and two churches.

Santorini was our next stop. Entering its bay on a boat is one of Greece's great experiences. Broken pieces of a volcano's rim—Santorini and attendant islets—form a multicolored circle around a bottomless lagoon that before the volcano's eruption (1635 BC) was the island's high center. Thíra,

or Thera, are the island's official and ancient names, respectively. Greeks, however, prefer its medieval name, Santorini, after St. Irene of Salonica, who died here in 304 AD. Firá, the capital, sits high on the rim; its white houses (many of which barrel-vaulted against earthquakes) seem to bloom like asphodel. To the east of Firá, the land smoothes out into fertile fields. A few bare cliffs push up again in the southeast. On one of them sits ancient Thera (ninth century BC), where naked boys used to dance in a traditional ritual. Akrotiri in the south, a Minoan town preserved in volcanic ash like Pompeii, continues to be excavated. Many of the finds are in Firá's Museum of Prehistoric Thera.

La (*Oía*), on the island's northernmost peninsula, is Greece's most photographed village. Nearby, beautiful *Skaftá* (dugout) houses, converted into highly sought-after accommodations, are a local specialty. There are also more places to stay and eat in Kamári and Perissa, two busy resorts on the east coast.

Small ferries and excursion boats pull in below Firá at Skála Firá, from where you ascend by donkey, by funicular, or by foot up a stone stairway. Big ferries anchor at Athinios, 10 km farther south. The most popular boat excursions offered are to Thirasía, Santorini's sleepy and beachless islet opposite Ía, and to the volcanic islets of Palea and Nea Kameni. The latter are in the middle of the submerged caldera, where passengers have the opportunity to bathe in hot mud springs or clamber over a still-steaming cinder cone.

Lesvos, Greece's third largest islet, is the antithesis of the Nisaki, or quaint little islet. Between its far-flung villages lie eleven million olive trees producing 45,000 liquid tons of oil per year. Its second industry is tourism. Nets to catch the "black gold" are spread in autumn, after the last charter flight of tourists has departed.

Early inhabitants were related to the Trojans. In the Iliad, the Achaeans punished Lesbos for siding with Troy. Natives were later

supplemented by Aeolian colonists. These founded six city states. The most important were E r e s s o s , M i t h y m n a , Antissa, and Mytilene. Each of them vied for p o l i t i c a l s u p r e m a c y. Lesbos emerged as the strongest. She developed a u n i f o r m c u l t u r e , nurturing such poets as Terpander and Arion well

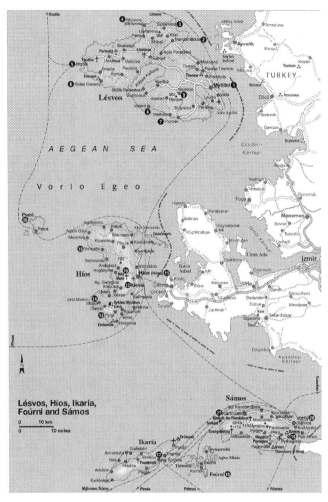

before Alkaios and Sappho who, in the sixth century, pushed lyric poetry to new heights. Meanwhile, their contemporary *Pittakos* initiated democratic reforms.

With its southern forests and idyllic orchards, Lesvos was a preferred Roman holiday spot. The Byzantines considered a humane exile for deposed nobility, while the Genoese Gattilsi clan kept a thriving court here for a century. To the Ottomans, Lesvos was "the Garden of the Aegean." Furthermore, it was their most productive, strictly governed, and heavily colonized Aegean island. After the eighteenth-century

reforms within the empire, a Christian land-owning aristocracy developed. It was served by a large population of laboring peasants. This quasi-feudal system made Lesvos a fertile ground for post-1912 leftist movements. For this reason, it became known as Red Island among fellow Greeks.

The years after 1912 also saw a cultural movement emerge. There were, for example, novelists like Stratis Myrivilis and Argyris Eftaliotis. However, since World War II, Lesvos's socioeconomic fabric has diminished considerably. This has been in large part due to emigration to 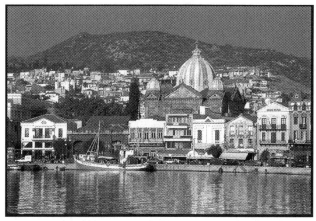 Athens, Australia, and America. Nevertheless, the founding here in 1987 of the University of the Aegean brought hope for a cultural revival.

Mytilini, the capital (its name is a popular alias for the entire island), is a port town of 30,000. It is interesting to stroll around, though few outsiders tend to stay. Behind the waterfront, assorted church domes and 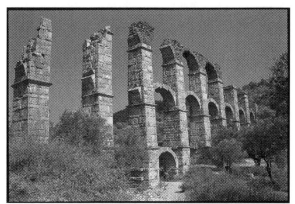 spires enliven the skyline. Meanwhile, Adós Ermoú, one street inland, threads the entire bazaar. It runs from the fish market to the now disused north harbor of Espáno Skála. It

also passes a mosque (ruined) and Turkish baths (well-restored). Behind the ferry dock stands the archaeological museum. It is spread over two premises. The new uphill annex features superb mosaics rescued from local Roman villas.

Also noteworthy are a pair of museums in Variá, 5 km south of town. The Theophilos Museum contains over sixty paintings by locally born Theophilos Hatzimihail, Greece's most celebrated native painter.

The nearby Theriade Museum was founded by another native son who, while an avant-garde art publisher in Paris, assembled this collection, with work by Chagall, Picasso, Rouault, Giacometti, Matisse, and Léger.

The road running northwest from Mytilini follows the coast facing Turkey. Mantamados, 37 km from Mytilini, has on its outskirts the enormous Taxiárdis Monastery with its much revered black icon. At Kapí, the road divides (see the map of Lesvos); the northerly fork is wider, better paved, and more scenic. As you continue across the flanks of Mount Lepétymnos, you pass by the handsome village of Sykaminiá and its photogenic tavern-studded fishing port, you descend to sea level at Mólyvos, linchpin of Lesvos's tourism and understandably so. The ranks of sturdy, tiled houses are an appealing sight, as is the stone-paved fishing harbor. Its days as a bohemian artists' and alternative activities' colony are over, however, with package tourism dominant since the late 1980s. Petra, 5 km south, accommodates the overflow on its long beach, while inland at the village center looms a rock plug crowned with the Panagía Glykofiloússa Church. At its foot, the eighteenth-century Vareltzídena Mansion is worthy getting a look at, as is the sixteenth-century frescoed Church of Ágios Nikólaus.

From Petra, head 17 km south to the turning for Limonos Monastery, home to an ecclesiastical museum. Then continue west toward the more rugged half of the island where you'll see lunar

volcanic terrain. Stream valleys foster little oases such as the one around Perivolís Monastery, which is 30 km from Limónos and is decorated with wonderful frescoes. Some 10 km beyond, atop an extinct volcano, the Monastery of Ypsiloú contemplates the abomination of desolation— complete with scattered trunks of the petrified forest and prehistoric sequoias, mineralized by volcanic ash.

Sigri, 90 km from Mytilíni, a sleepy place flanked by good beaches, is very much the end of the line and is guarded by a Turkish-built fort. Most prefer Skála Eressoú, 14 km south of Ypsiloú, for its beach. Numerous lesbians come to honor the poet Sappho, who was born here.

Southern Lésvos, between the two gulfs, is home to olive groves rolling up to 968-meter Mount Olympus. Plomari on the coast is Lesvos's second town, famous for its ouzo industry. Most tourists stay at pebble beach Ágios Isídoros, 3 km east, though Melínda, 6 km west, is more scenic. Vatera, whose 7 km sand beach is considered the best on the island, lies still farther west. In route, we stopped for a soak at the restored medieval spas outside Lisvóri and Polichnitos.

Inland from Plomári, we saw the remarkable hill village of Agiásos, nestled in a wooded valley under Olympos. Its heart is the major pilgrimage church of Panagía Vrefokratoúss, which comes alive for the August 15 festival, one which we managed to attend.

In Psará, scarcely 350 inhabitants remain. Melancholy—its bleakness is relieved by occasional fig trees and odd cultivated fields. Besides the lone port village, there is just one deserted monastery in the far north. Six beaches lie northeast of the port, each better than the other, though all catch tide wrack on this exposed coast. A few tourists trickle over from Híos on regular local ferries from Híos Town.

Although the Híos of today differs from the Chíos of antiquity, a quick glance will allow you to distinguish the new from the old. The

Genoese seized control here in 1346; the Giustiniani clan established a gum mastic business, the maona, which controlled the highly profitable trade in gum mastic. During the rule of the Guistiniani, which also saw the introduction of mandarin fruit, Híos became one of the wealthiest and most cultured islands in the Mediterranean. Local process in navigation was exploited by 150 ships calling here annually. And Christopher Columbus apocryphally came to study with Híot captains prior to his voyages.

In 1566, the Ottomans expelled the Genoese but granted the islanders numerous privileges so that Híos continued to flourish. In March of 1822, however, agitators from Sámos convinced the Híots to participate in an independence uprising. Sultan Mahmud II, enraged at the Híots' ingratitude, exacted a terrible revenge. Híos had only partly recovered when a devastating earthquake in March of 1881 destroyed much of what remained. Oddly enough, Híos and its satellite islet, Inoússes, are home to some of Greece's wealthiest shipping families.

Our cruise was now coming to an end. Having disembarked in Lesvos, we left our ship there and visited that island by bus. Next, we made use of the ferry to visit Híos and Sámos, respectively, and to subsequently regroup with our ship in Lesvos.

From Lesvos, we would journey westward in the direction of Sporades and Évia, pass through the narrows that separate Évia from the mainland, and then we would head southwest to Halkida and finally to Athens.

At the airport in Athens, the passengers all went their separate ways. Some returned to their countries of origin. Others connected with flights that would take them to other destinations. I left for my home in the San Francisco Bay Area.

During my return flight, I had an abundance of time to reflect on the cruise. I thought of the beautiful sites we saw and the hospitality of the Greeks and the Turks. However, what impressed me the most was the antiquity of the sites we saw, as well as taking into consideration the heights that the ancient people of this book reached at such an early time in history.

Printed in the United States
By Bookmasters